Catalogue of the exhibition held in the Biblioteca Medicea Laurenziana
from 1 April to 15 July and from 2 September to 31 December 2007
with the contribution of Mandragora and Opera Medicea Laurenziana.

Exhibition concept and design
Fabrizio Monaci, Roberta Paganucci

Photographs
Biblioteca Medicea Laurenziana, Florence
By permission of the Ministero per i Beni e le Attività Culturali.
Unauthorized reproduction is strictly prohibited.

Mandragora s.r.l.
piazza del Duomo 9, 50122 Firenze
www.mandragora.it

English translation by
Jeremy Carden, Andrea Paoletti

Edited, designed and typeset by
Monica Fintoni, Andrea Paoletti, Paola Vannucchi

Printed in Italy

ISBN 978-88-7461-098-3

BIBLIOTECA MEDICEA LAURENZIANA

THE LIBRARY ON DISPLAY

imaginary creatures

Mandragora

PREFACE

In the last ten years, thanks to government funding and private donations, including a decisive contribution from the Ente Cassa di Risparmio di Firenze, the Biblioteca Laurenziana has been able to embark upon a series of conservation measures—a long-term programme not dictated exclusively by emergencies—, the aim being to bring the Library's significance as a monument into clear focus.

The vestibule has been cleaned and enhanced by the restoration of the 20th-century *trompe-l'œil* ceiling. Encrustations and incongruent fittings have been removed from the staircase. The state of conservation of the *plutei*, the famous wooden stalls of the Reading Room, has been assessed and monitored, and an intervention procedure devised that can be used for the entire complex. Finally, it has been possible to tackle, with a team of scholars, art historians and restorers, the serious problem of the dilapidated and seemingly irreversible state of the 16th-century stained-glass windows. The restoration has remedied, as far as is possible, the ravages of time, eliminating the crude sutures marring the delicate, rich decoration of the glass. The restoration work is almost at the half-way point—the majority of the windows on the left-hand side of the library have now been completed—and it will not be difficult, having found effective means of protecting the glass from harmful external agents and ambient conditions, to complete the project with the funding that has already been made available.

Although the conservation of the Library as a monument has been a major undertaking, sight has not been lost of the primary function of the building. In this same period, thanks to the opening of a reading room suitable for modern needs, the updating of available research tools and the gradual, on-going computerization

of the catalogues and bibliography (which can now be accessed through the Internet), the Biblioteca Laurenziana has become a centre of learning greatly valued and appreciated by scholars from round the world.

With the assistance of experts in the field, and often in conjunction with Italian and foreign research institutions, annual exhibitions of manuscripts have been organized, accompanied by catalogues which have become irreplaceable points of reference in the available literature on the subject. The librarians who have contributed to these events have tried to shape them so as to attract the general public to what, even in the rich panorama of Italian libraries, is a quite unique monument. It is worth recalling here that Michelangelo, the greatest architect of all time, designed his secular masterpiece together with the Medici Pope Clement VII to house and make public the world's most extraordinary collection of manuscripts, which has come down to us almost intact from the second half of the 15th century.

With the opening of *Imaginary Creatures*, the first of a series of theme-based projects that will form a permanent exhibition, the Library is 'showing itself off' to the full. Visitors who have selected Michelangelo's staircase from amongst the masterpieces recommended in the guidebooks, instead of admiring it from a distance as if it were one of the artist's famous sculptures, will be able to climb its steps—with the care that is due to art works—, walk through the Reading Room with its original lighting and consider the *plutei* there not as semi-mysterious objects but as practical items of furniture for studying and preserving the manuscripts they will find on display in the first of the recently renovated exhibition rooms. The enduring interaction of the artistic/architectural component with the manuscripts and books will enable visitors to appreciate what Michelangelo's library is all about—reminiscent of the great examples of Cesena and San Marco, it is a genuine landmark in library architecture in the period between the medieval and the early modern age.

The permanent exhibitions, which will alternate with temporary ones generally associated with the activities of specialist committees, with particular events or with the conclusion of research programmes, will be organized around themes carefully chosen to provide a glimpse of the wealth and variety of a cultural legacy that encompasses different languages and geographical areas over a period spanning at least twenty centuries.

Imaginary Creatures is a representative selection consisting of 19 manuscripts and 9 printed books dating from the end of the 12th to the 18th century. They are in Latin, Greek, the Italian vernacular and Persian, and were originally produced in Italy, France, Holland and Iran. Picked out from different collections belonging to the Library, they have been chosen for the astonishing range of imaginary creatures depicted in them.

6

Sirens, satyrs, dragons, centaurs, phoenixes, unicorns, basilisks, winged horses, griffins and minotaurs of all shapes and sizes, and executed in different techniques, explain and embellish the texts, but are also elements of an allusive language that intrigued the reader, arousing a sense of marvel at a world where the boundaries between the real and the imaginary became imperceptibly blurred.

Drawn from classical mythology and subsequently often endowed with Christian connotations, these zoomorphic figures were a splendid challenge for the artists that illuminated or printed them. Some relate more or less faithfully to the text, for instance the remarkable winged beast illustrating the opening lines of Horace's *Ars poetica* (Plut. 34.12) or the basilisk of the *Hortus Sanitatis* in the 16th-century printed book 22.3.1. Others echo antiquarian motifs, such as the centaurs in the heraldic folio of Plut. 79.1, which belonged to the humanist Francesco Sassetti. Others again have an allegorical meaning, for instance the unicorns hauling the cart in the *Triumph of Chastity* of Med. Pal. 72, illuminated by the Florentine artist Apollonio di Giovanni. Finally, there are some creatures that have no real or apparent relationship with the text itself but serve to decorate the page or identify the printer, for instance the griffin on the title page of Macrobius' *In Somnium Scipionis* in the 16th-century 15.F.6.11 printed by Giovanni Griffio the Elder.

The librarians who planned the exhibition of manuscripts and printed books and have organized it with their usual professionalism would like to dedicate this companion catalogue to their colleagues Luigi Marraffa and Carlo Terracciano, who died recently.

Franca Arduini
Director, Biblioteca Medicea Laurenziana

Catalogue entries

E.A. Eugenia Antonucci
L.B. Luciana Bigliazzi
A.R.F. Anna Rita Fantoni
S.M. Sabina Magrini
I.G.R. Ida Giovanna Rao
A.S. Anna Scarlino

MANUSCRIPTS

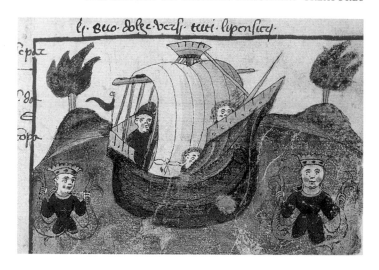

1. *Story of the Trojan War*

Florence, Biblioteca Medicea Laurenziana, Mediceo Palatino 153
15th century

This prose version in the Venetian dialect is based largely on the *Historia destructionis Troiae* written by the jurist, poet and Latin prose writer Guido delle Colonne from Messina between 1270 and 1287, but also incorporates additions stemming from different medieval traditions. The work of a single hand, the text is accompanied by unpretentious yet lively coloured drawings, also traceable to a Venetian milieu.

The manuscript is open at fol. 103r, which describes and illustrates Ulysses' encounter with the Sirens.

[A.R.F.]

quandosse ogni altra cossa cogni
altro suo ponsiery. Et se alguno
no li obediua. Et perfecte elle li
feua auentar de homeni bestie
e questo sera p arte de astrolomia
mo. una. de quele done laqual a
ucua nome zezelos quando sua
morada. Amj. mco una soa pu
pom cole. T aidie dla soa ra
mela. Et sime prepe e tal muodo
che ben uno. Ano. dlongo so piti la
chio. nome puc partir dacsso
E en fra questo tenpo ella se in
grauida Amj. Et fece uno fiol
mascholo. loqual dapuo crese
e uene molto fortissimo. Et soli
luy. chura zercha loproposito
dlasmia partida mo zercelos qua
do. ella. sepe. chio. me boleua par
tir. se choroza. Amj. Et retene
tegnir. colsuo. T chantorneli. e so
rumol mete. chio sera amaistrado
T querlarte. p uertue dlomen ope
cazeo. so dstipt tute soe inca
tazion.

Como uliese. co lasoa arte se par
ti. dale spole. Dle serene

O la partadosse lo ditto uliese. do
quella spola dquele fade.
chusi. nauegando. coliguo copa

gni. lozonse. auna spola. duno
santo orachulo. loqual p diuino
posanza. adalguno daua respo
sta. Achilo domadaua et so uliese
lo domadic. dmolte cosse infra le
altre. cosse. dlequal so domadic
zo che luignezaue. Dapuo lamo
rete. dle nostre Aneme dlequal
so no puy. Auer resposta. cozosio
chio. mefosse. partido dacllo co
uento. Et sagodo. Et uiny in uno
pericoloso. luogo. dmar in log
ual mare. sera domolte serene
dlequal. dalo boligado. T lupo. el
era. femena. e dalo boligolo T zoxo
sera pesie. Et quele serene cataui
si. gloriosa. mete. chli mi pey
nauegadory. che uignelua y mare
quado. elli uignelua. y aschoitare
sono. prega. d tanta dolceza. chely
lassa leualle. dle naue. e messe
zopo. etremj. oltrosi. dlassa. d naue
gare. equolo. cato. T zuriaua. coto
li. Anemi. dly omeny. che oldando
li. suo. dolce versy. tuti lipensiery.

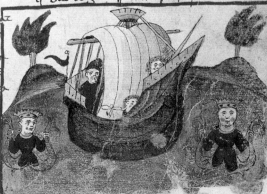

103

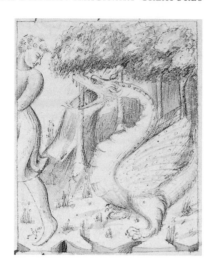

2. Miscellany

Florence, Biblioteca Medicea Laurenziana, Ashburnham 649
15th century (1460)

The codex contains various vernacular texts, including the *Libro della natura degli animali* (also known as the Tuscan Bestiary), a medieval treatise probably composed towards the end of the 13th century in which the physical description of the animals is accompanied by a moral interpretation. The large number of extant manuscripts is a clear indication of its enduring popularity.

The manuscript is decorated with pen drawings, possibly executed by an artist of the Sienese school. It is open at fol. 14v (opposite), where a siren illustrates Chapter XVI. Above, a detail of fol. 12r, depicting a dragon.

[A.R.F.]

rena e ingannato che chi disse a
more e preso ben puo dire chesia mor
to in tutti glialtri suoi fatti sicome
dice in unluogo chte damore preso
arivato one a mal porto alloranone
in sua balia e chi persua mala uentu
ra morisse in quel stato si puo ben di
re chesia morto lanima elcorpo.

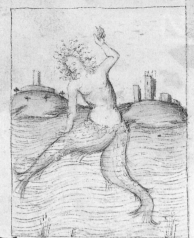

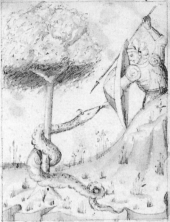

LA serena sie una creatura
molto nuoua chelle dite ma
niere luna sie meza pescie eme
za femina. Elaltra sie meza ca
uallo emeza fatta come femina. E
latra sie meza uciello emeza come
femina. Equella che e come pescie
sia sidolce canto che qualunche huo
mo lodisse sie mestiero che aprossi
mandosi luomo aquesta uoie similli
adormenta. Equando ella lauede a
dormento silsua sopra e uccidelo
Equella che meza euuallo si suona u
no sono ditruonba che simigliante
alatronba esidolcemente lasuona
che uccid luomo. Equella che meza
uciello si fae uno sono amodo chedar
pa cintal maniera losuona che nel uo
mo tradito emorto. Equeste serene
potiamo noi assimigliare ale femine
che non sono dibuona conuersatione
che ingannano gliuomini liquals si
namorano diloro menalmente oper
qualunq ragione gliuomini lina
morano diloro oper beleza opcui
sta chella faccia operparole ingan
neuoli chella dicha si si puo luomo te
nere morto si come colui che dalasse

UHo sergente loquale elsuo
noe sichiama aspio equesto si
guarda larbore ladue situo
ua lebalsimo ede si coudele che noncho
mo si arduo dacostaluisi perprendare
elbalsimo segia loserpente uondor
misse epero singegnia come lopossa
fare adormentare. Epiende una ar
pa oaltro stormento esiluae asonare
apresso diluj pchelli sadormenta. Elo
serpente uedendo che luomo uiene
pertollerli quello che guarda sistura
luna orechia colacoda elatra perquo
te tanto interra che sempre tutta di
rena sicho ilsuono dilostormento nolle
puo adormentare. Equesto serpente
sie assimigliato aduna matera digrien
ti chesonno pieni dauarizia edicupi
dimde che non pongono mente alde
sto dalcuno bono huomo equando lo
buono predicatore predica lesancte
parole sisi puo bene dire dolce esoaue

3. Petrarch, *Trionfi*

Florence, Biblioteca Medicea Laurenziana, Strozzi 174
15th century

Written in calligraphic *mercantesca* script with humanistic features and bearing the subscription of the scribe, the money-changer Bese Ardinghelli, the manuscript contains Petrarch's *Trionfi*, preceded by eight folios with sonnets and portraits of famous figures. The illustrations for the *Trionfi* have been attributed to the Florentine artist Apollonio di Giovanni (1415/17–65), an illuminator and painter who specialized in the decoration of bridal chests, *spalliere* and devotional paintings.

Fol. 28v depicts the *Triumph of Chastity*, impersonated by the poet's beloved Laura, who is standing on a cart hauled by two unicorns; the naked figure of the defeated Cupid can also be seen kneeling on the cart. According to the tradition of medieval bestiaries, unicorns could only be tamed by virgins, and therefore evoked purity.

[S.M.]

Entanto pur fogniando libertate
l'alma chelgram Cristo fea pronta eleue
confolai colueder lecofe andate
Rimirando era io facto alfol bineue
tanti spiriti et fichiari ilcacciar tetro
quasi lunga punctura intempo breue
Chelpie uaimnaner eglocchi torna adretro

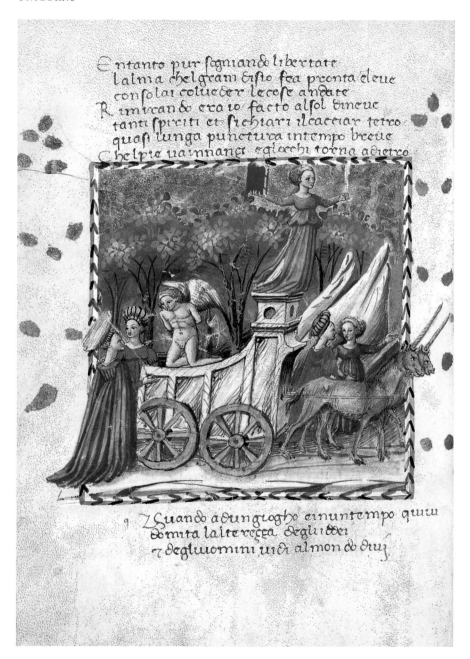

9 Zguando adungioghe einuntempo quui
domita laiterecca degliuden
7 degliuomini uidi almon do dui

4. Dante, *Commedia*; Petrarch, *Trionfi*

Florence, Biblioteca Medicea Laurenziana, Mediceo Palatino 72
15th century (1442)

The codex originally belonged to Guido di Francesco Baldovinetti (whose name appears on fol. 88r), and was written by the Florentine scribe Bese Ardinghelli; the latter's signature is found at the end of each work—the *Commedia*, completed on 9 May 1442, and the *Trionfi*, on 16 May of the same year. The illuminator has been identified as Apollonio di Giovanni. Historiated initials narrating Dante's journey through Hell and Purgatory and finally to Paradise mark the beginning of each canticle; the six *Trionfi*, on the other hand, are preceded by allegorical illustrations.

The manuscript is open at fol. 78v, which features the beginning of Petrarch's *Triumph of Chastity*, who is depicted standing on a cart being hauled by two unicorns, emblems of purity and virginity.

[E.A.]

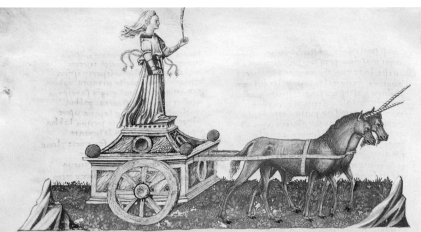

TRIVMPHO SECONDO DELLA CASTITA

Quando adungiego uiuntempo quiui
domita laltreregia degliddey.
z degliuomini uiui almodo duy

E presi assempreo deloro stati rey
faccendo mio profecto laltrui male
inconsolare icasi z dolor miei

C hessio ueggio dunarco z duno strale
ferbo prosso elgiouane dabido
lun decto deo laltro huom puro mortale

E t, ueggio aunlacerïuol guinone z Dido
camor pio delsuo sposo amorte spinse
nö quel de Nea comel publico grido

N onmi debbio dolere saltri miuinse
giouane incauto disarmato z solo
z sellamia nimica amor nostrinse

N o e ancor giusta assay eaglio diduolo
chennabito tre uïdi chio nepïansi
stolte gloria lali elguec auolo

N s coaltro romor dipecto dansi
duo leon feri odio folgori ardenti
chaciolo zterra z mar dove luego fansi

C hio uidi damor contuiti stuoi argomenti
muouer contracolei dichio ragiono
z ley pösta assay piu cheflamme ouenti

N onfan sigreamde zst terribil sono
et, naqualor dienchelade z pïupossa
Stilla z caretti quando urate sono

C heïe maggiore ïsullaprima mossa
nö fosse deldubbioso z graue assalto

chi nonorede chrïredue sappa nepossa
C iascum psë streitraeua malto
pueder meglo z leuror dellampresa
icor zglcchi auea facto dismalto

Q uel uincitor cheprima era alloffesa
daman ãx tra lostrale dalaltra larco
z lacorda allorecchia auea giatesa

N ö corse mai siliee meïe aluarcho
duna fugace certiia unleopardo
libero inselua obteatene scarcho

C hensö fosse stato uiu lento qtardö
tanto amor pronto uenne allei serire
caluolto alle fauille onsto tuctardö

C ombattea inme cölapieta ildistre
chedolce mera sisacta compagna
duroauedersla intalmoss perire

M auritu chedabuon nonsisicompagna
mostro ashquel punto ben conlagratorto
chi abandona lei dalreui silagna

C hegiamai schermidor nonsu si acorto
aschisar colpo nenochïer sipresto
auolger naue dagliscgli imporco

C omuno schermo intrepidö z honesto
subito ricopse quel bel uiso
dalcolpo achi latten de agro z funesto

F era alsin conliocchi z coloce fïso
speando lauictoria ondesser sole
z uïnonesser piu dalleï diuïso

C ome chisimisutratamente cole
chascripte inangi chaparlar comincï
neglcchi z nella fronte leparole

V oleua io due signor mio sette uïng

5. Astronomical miscellany

Florence, Biblioteca Medicea Laurenziana, Pluteo 89 superiore 43
second half of the 15th century

Written for the Medici in humanistic script by an anonymous scribe who worked extensively in Florence for the writer and bookseller Vespasiano da Bisticci, the manuscript contains a collection of texts about astronomy: Germanicus' *Aratea*, with the *Scholia Sangermanensia*; excerpts from Pliny the Elder's *Natural History* and Martianus Capella's *De nuptiis Mercurii et Philologiae* ('The Marriage of Philology and Mercury'); and an incomplete version of Hyginus' *Poetica astronomica*.

The creature on fol. 43r illustrates ll. 359–61 of the *Aratea*, which describe the constellation Cetus (Whale or Sea Monster); in Greek mythology, this was the beast to which Poseidon requested that Andromeda be sacrificed, and which was subsequently slain by Perseus. The sea monster has been represented in various ways down the ages: as a fish-dragon, as a sea serpent covered with scales bound up in enormous coils, simply as a whale, but also as a hybrid sea and land creature with its front paws pointing forwards. It is depicted here as a dragon amidst the waves.

[S.M.]

18

sola ypermestra linceum seruauit : ob id illis
fanum factum est · cetere uero dicuntur apd'
inferos in dolium ptusum aquam ingerere · ┼
Nauis autem habet stellas in puppe quatuor :
in catastroma quatuor · in malo summo tres :
in singulis themonibus quinq; Sub carina ┼
quinq; Sunt omnes · xxi ·

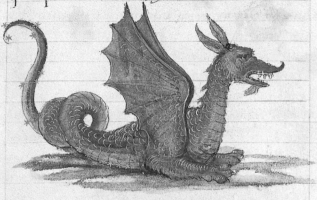

Dt uerso posita et boree uicina legenti
A uster pistris agit · duo sidera plegit : unum
N amq; aries supra pistrum piscesq; feruntur
B ellua sed ponti non multum preterit amnem

Po rro sub ariete et piscibus super fluuium cetus
in celi regione collocatus est · dicitur autem

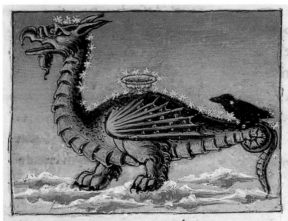

6. Matteo Palmieri, *Città di vita*

Florence, Biblioteca Medicea Laurenziana, Pluteo 40.53
15th century (1473)

Written by Neri di Filippo Rinuccini—under the pseudonym "Omnium rerum vicissitudo" ('All things suffer change', from a famous line in Terence's *Eunuchus*)—in imitation of the *Divine Comedy*, the *terza rima* poem *City of Life* is accompanied by a commentary in Latin by Leonardo Dati, Apostolic Secretary and Bishop of Massa. The presence of both a Latin and a vernacular version of the poem is a reflection of the continuing debate over the literary merits of the two languages, which had remained unsolved following the failure of the Certame Coronario, the public poetry competition held in Florence in 1442. The codex, which the author hoped would bring him glory but in fact, despite its wide circulation, attracted charges of heresy, was richly illustrated—terrestrial and celestial spheres enveloped by the empyrean, zodiacal signs, symbols of the constellations, with the planets sometimes defined by the gods of classical mythology—by the painter Francesco Botticini, who on this occasion turned his hand to illumination.

The folio on display (46r) features the constellation Ophiuchus (Serpent Bearer, Lat. *Serpentarius*), part of which resembles a dragon.

[I.G.R.]

Hoc signum tantum signorum longitu-
dinem occupat cancer s. leonis & uirginis
& ita collocatur ut caput ad signum an-
eandem extendat & extremum caudae ad
sagittary caput supponat & recuruatur
etiam & in prima p eius curuatura crate-
rem habet in inferiore uero coruum que
omnia scribit auctor Cicero de natura de-
orum q his sese de p\[ar]tibus eruitur ydra
in medicis situ fulgens cratere lucet extre-
mam nitens plumato corpore coruus.

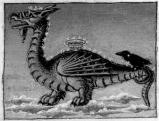

Stellarum s. in quo predicte omnes sunt
stellarum ymagines que omnes figurant
numero M xx ij ut maiores nostri proba-
uerunt unde albumasar lī ij dicit Mille
& quinti nouem stellas esse de quibus no-
tas habemus quarum septem planete sunt
relique omnes in stellato caelo numero
M xxv j Aulus gelbus noctium atticar-
um lī xiiij disputans aduersus eos qu
uentura per stellas predicere p̄sumunt
postq̄ plura argumenta inducit hec re-
fert Fauorinus phylosophus affirmabat
stellas istas quas num erraticas ingendi ue-
ro errones uocat non esse plures q̄ uulgo
dicerentur posse tamen fieri existimabat

ut & alij quidem planete pari
potestate essent sine quibusrec
ta atq̄ perpetua obseruatio per
fieri non quirent neq eos cerne
re homines possent propter
exuberantiam splendoris suae
altitudinis & & C quo non
tura deorum. ut ille licet
omni descriptio syderum atq̄
tanti caeli ornatus temere &
casu potuisse effici una sane
mentum uideri non potest. que
enim natura mentis rationisq̄
expers hec efficere potuit que
non modo ut fierent ratione
egerunt sed intelligi qualia
sunt sine summa ratione non
possunt. Et hoc dixit ut osten-
deret maximum esse stellarum
numerum & uarios caelorum
cursus ornatusq̄ quorum non
uam nullam habemus s licet se-
cundum materiam presentis
operis intelligi possit ab eius uf
supra quo in loco commorare
animas dixit anteq̄ corporib'
infundantur tamen latius in-
telligendum est que deus po-
suit supra cogitationem homi-
num inquirenda non esse &
maxime que deus ascondit in
sua infinita potestate. Ad il-
lam siluam obscuram quam
ylem a grecis uocari supra mo-
strauimus quo in loco perdiffi-
cile est noscere uera bona. o

7. Firdawsī, *Shāhnāmah* or *The Book of Kings*

Florence, Biblioteca Medicea Laurenziana, Orientale 5
16th century (29 October–26 November 1582)

This sumptuous edition of the *Book of Kings*, the great masterpiece of Persian epic poetry composed by Abū'l-Qāsem Mansur (better known as Firdawsī) around 994–1009, is extensively interpolated with episodes from two other epic poems narrating the saga of Garshāsp and the saga of Sām. Written in fine *nasta'liq* script and richly decorated with exquisite paintings (which may have been produced in the ancient capital city of Shīrāz), the manuscript was probably a gift from the Ottoman captain of the fleet (and later grand vizier) Kara Mustafa Paşa (1635–83) to the Grand Duke of Tuscany Ferdinando II, which would explain how it found its way into the Medici collections.

The folio on display (420v) features the scene in which the hero Garshāsp wounds the dragon of Mount Saqīlā in the throat. The slaying of the dragon is a recurrent theme in Persian epic poetry.

[S.M.]

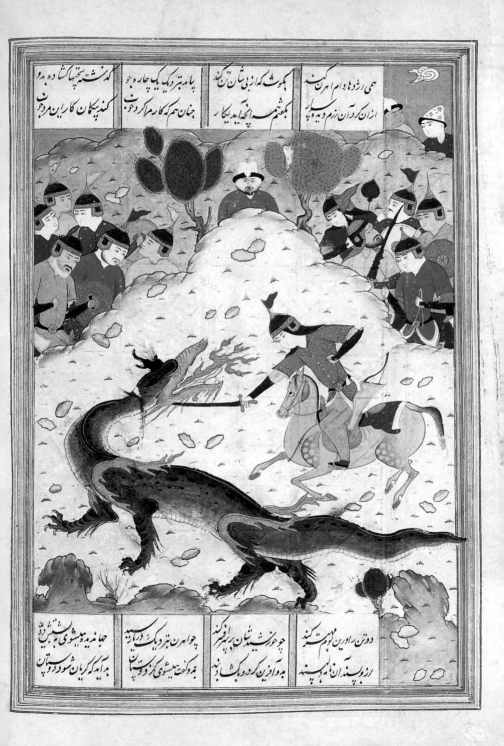

8. Aristotle, *Nicomachean Ethics*; *Oeconomica* (attr.); Leonardo Bruni, *Isagogicon*

Florence, Biblioteca Medicea Laurenziana, Pluteo 79.1
15th century (early 1470s?)

Written in humanistic script and illuminated in Florence for Francesco Sassetti (1421–90), humanist and trusted banker of the Medici family, the manuscript contains Aristotle's *Nicomachean Ethics*, translated from Greek into Latin by John Argyropoulos, and two works by Leonardo Bruni: the *Isagogicon moralis disciplinae* ('Introduction to Moral Philosophy') and the Latin translation (from the Greek) of the pseudo-Aristotelian treatise *Oeconomica*.

One interesting feature of the codex is Sassetti's ex-libris inscription on fol. Iv, on display here. A complex heraldic composition with a wealth of antiquarian and classicizing motifs, it includes a roundel with the name FRANCISCI SASSETTI, a cartouche bearing the motto *A mon povoir* supported by two putti, and the family device—a sling and stones—resting on a small fluted vase held by two centaurs. The putto and the centaur on the left are also holding slings and stones.

[S.M.]

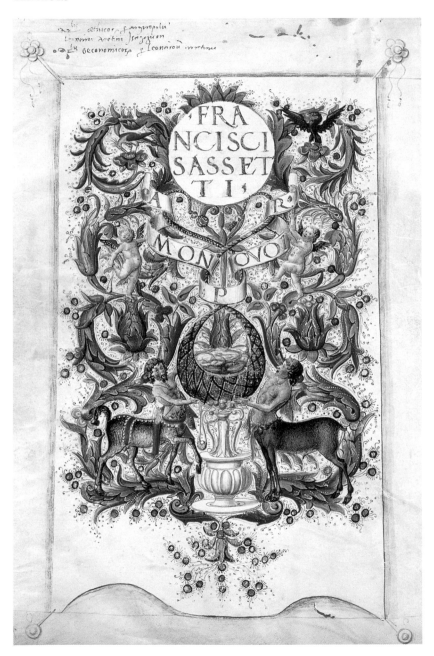

9. Medical miscellany

Florence, Biblioteca Medicea Laurenziana, Pluteo 73.16
second half of the 13th century

This edition, in which the *Herbarium Apulei* is complemented by a number of minor treatises, derives from a collection assembled in late antiquity which circulated widely in the Latin West during the Middle Ages. Recently dated to the 'Swabian period', the countless illustrations of the therapeutic properties of medicinal herbs, complete with information on dosages and how to administer them, have been attributed to artists active in the Campania region of south-western Italy. The scenes, traditional but very lively, combine the languages of mythology and science, popular belief and practical experience.

The codex is open at fol. 142v, where a centaur, "magister medicine", is presenting the "herba erifion".

[I.G.R.]

Precatio eiusdem herbe.
Herba erifion ut advsis me rogante et cu gaudio
ut tua pisto sit et ea omia psanes que scolapius
aut chiron cetaur° magr medicine de te advenit
nascit in gallia imonte siracti figura vt apii.
flore simile nasturtii septe radicib totide ra
mulis ipa aut patula humo asperis minimi
que omi tempore florens est. sem vt taquam
fabam.

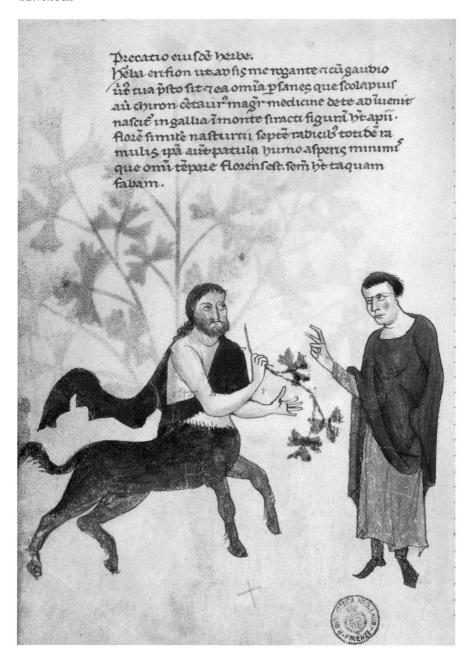

10. Virgil, *Aeneid*

Florence, Biblioteca Medicea Laurenziana, Pluteo 39.6
second half of the 15th century

The codex was probably written in the 1480s by Alessandro da Verrazzano (or Antonio Sinibaldi) for Francesco Sassetti, whose family device, flanked by two superb peacocks, can be seen in the lower margin of fol. 1r. The miniatures are now thought to be by Mariano del Buono, who is currently regarded as one of the most influential figures in Florentine illumination in the second half of the 15th century. The opening folio is decorated with a richly decorated border illustrating episodes from Virgil's poem. Illuminated initials in gold mark the beginning of each book.

The work is open at the beginning of Book XII (fol. 160v), where the initial *T* is flanked by two ornamental centaurs.

[E.A.]

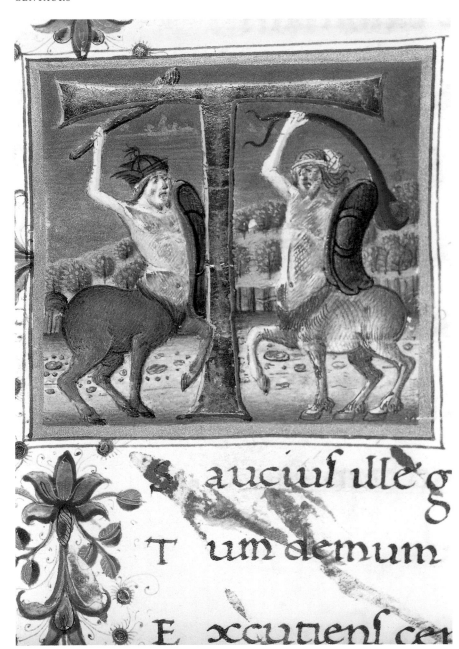

S aucius ille g

T um demum

E xcutiens cer

11. Selected works by Horace

Florence, Biblioteca Medicea Laurenziana, Pluteo 34.12
end of the 12th century

Written in Italy in Gothic script (*littera textualis*), the manuscript contains a collection of works by Horace (*Carmina, Epodon liber, Carmen saeculare, Ars poetica, Sermones, Epistulae*) intended for school use.

The folio on display is 61v, where, serving as an illustration to the first five lines of the *Ars poetica* that follows in the codex, there is a depiction of an imaginary creature with a woman's face, the neck of a horse, the breast, talons and wings of a bird, and a fish tail. This monster is not found in classical mythology; it was invented by the poet as an example of abnormal, and hence ridiculous, painting, the intent being to condemn any form of artistic production that goes beyond the bounds of reason. The creature proved popular, and appears in many manuscripts of Horace's works from the 11th century onwards; however, not all the examples have the same wealth of detail found in the Laurentian manuscript. Note, for instance, the letters on the face and around one of the tresses, which form the word CAMENA (Muse, Poetry).

[s.m.]

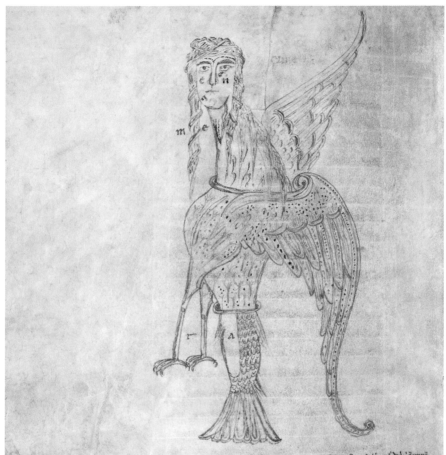

[manuscript text, largely illegible]

12. Cecco d'Ascoli, *Liber acerbe etatis*

Florence, Biblioteca Medicea Laurenziana, Pluteo 40.52
second half of the 14th century

The codex is one of the fourteen earliest extant manuscripts in the extensive tradition of this celebrated vernacular encyclopaedic poem dealing with the natural sciences, physics and religious philosophy, written in six-line stanzas by the physician and 'magician' Francesco Stabili, known as Cecco d'Ascoli, who was eventually condemned for heresy and burnt at the stake. The particularly rich and complex decoration found here was executed by two different artists, probably from (or active in) the Lombardy region. It is worth recalling that the section devoted to the bestiary was used as an iconographic source by Leonardo da Vinci.

The manuscript is open at fol. 33r, which features a delicately rendered phoenix (opposite). On the following pages, other imaginary creatures: a griffin (fol. 41v), a siren (fol. 43v) and a dragon (fol. 46r).

[I.G.R.]

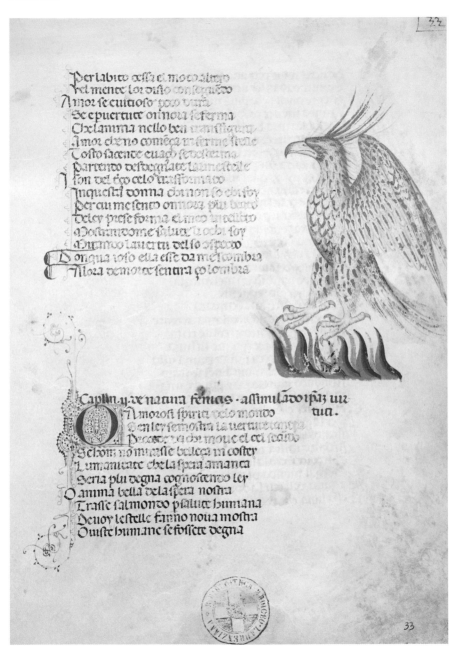

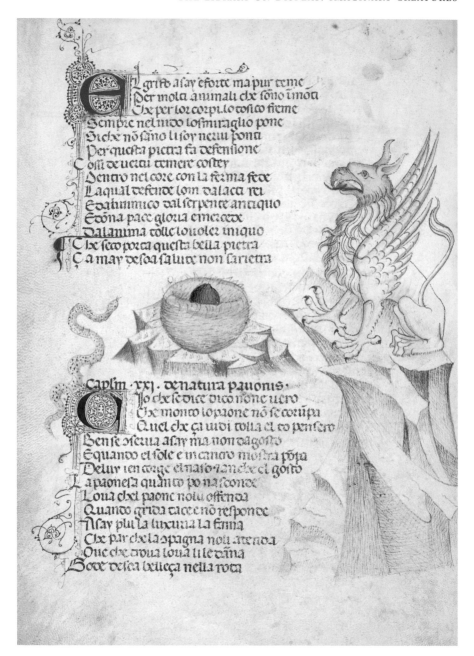

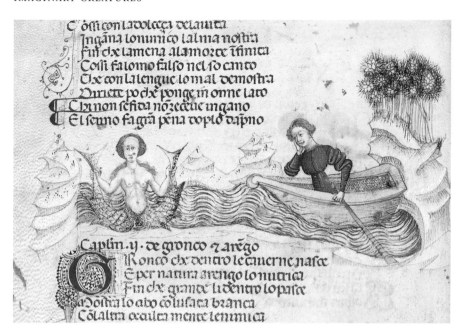

Cossi con la dolcecza de la vita
Inganna lo nimico l'alma nostra
Fin che la mena a la morte trinita
Cossi fa l'omo falso nel so canto
Che con la lengua lo mal demostra
Dirieter po che ponge in onne lato
Chi non se fida no receve inganno
El senno fa gran pena tropo danno

Caplm .ij. de gronco z arego
Ronco che dentro le caverne nasce
E per natura arengo lo nutrica
Fin che grande li dentro lo passe
Nostra lo abo colui faca brancha
Co l'altra ocultamente le nimica

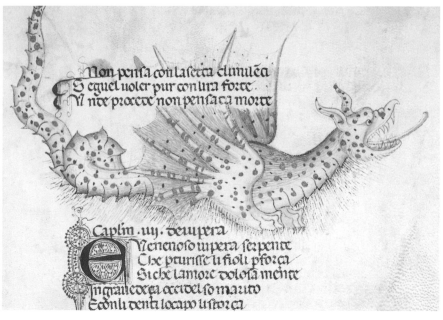

Non pensa con la saetta che m'uccha
Seguel voler pur con ira forte
Al nde procede non pensa la morte

Caplm .iiij. de vipera
Venenoso vipera serpente
Che partisse li fioli per forca
Si che l'amore dolosa mente
Ingravidera occide lo marito
E conli denti lo capo li straccia

13. Domizio Calderini, *Commentarii in Satyras Iuvenalis*

Florence, Biblioteca Medicea Laurenziana, Pluteo 53.2
15th century (1474)

Dedicated to Giuliano de' Medici, this manuscript containing Calderini's commentaries on the *Satires* of Juvenal passed into the possession of his brother Lorenzo after the former had met his death as a result of the Pazzi Conspiracy (1478). It was produced by two prominent members of Cardinal Francesco Gonzaga's circle, the scribe Bartolomeo Sanvito and the illuminator Gaspare da Padova. They were undoubtedly supervised by Calderini; the manuscript contains a number of marginal annotations in his hand.

Depicted on fol. 5r, on display here, is one of the most famous scenes in the history of the illuminated book. The satyrs frolicking in a rural setting are modelled on a Roman sculptural work known as the *Satyrs of the Valley*, dating to the 2nd century AD and presumed lost; this scene is one of the first indications that it had been rediscovered in the 15th century.

[I.G.R.]

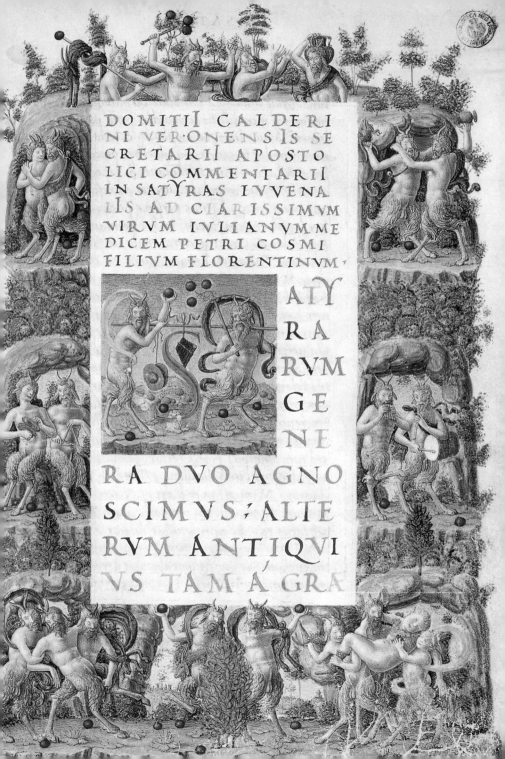

DOMITII CALDERI
NI VERONENSIS SE
CRETARII APOSTO
LICI COMMENTARII
IN SATYRAS IVVENA
LIS AD CLARISSIMVM
VIRVM IVLIANVM ME
DICEM PETRI COSMI
FILIVM FLORENTINVM·

ATY
RA
RVM
GE
NE
RA DVO AGNO
SCIMVS; ALTE
RVM ANTIQVI
VS TAM A GRA

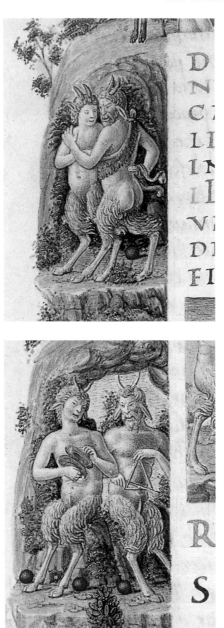
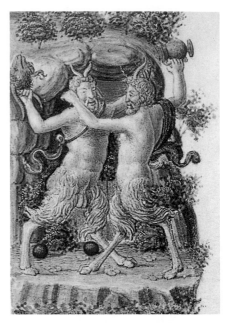
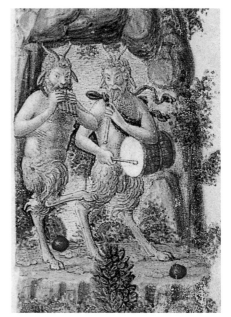

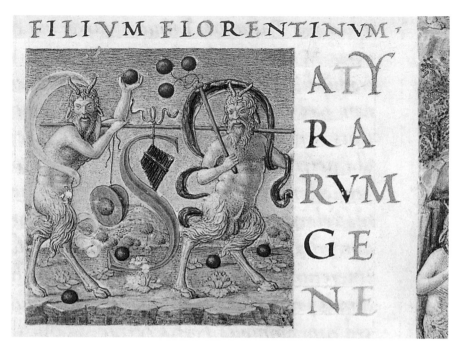

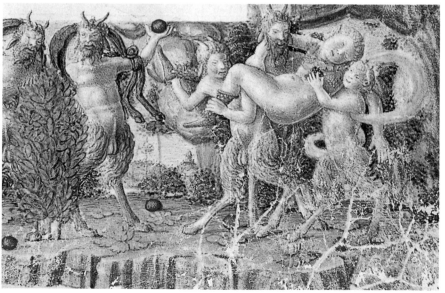

14. Alchemic miscellany

Florence, Biblioteca Medicea Laurenziana, Ashburnham 1166
second half of the 15th century (1460–75)

Written in a late Italian Gothic script, the codex is illustrated with images of excellent workmanship but uncertain origin—they have been variously attributed to the circle of Pisanello in northern Italy, to Florentine artists influenced by the work of Botticelli, to the school of Squarcione and Mantegna in Padua and to the workshop of Iacopo Bellini.

The folio on display (18r) features "Pan silvanus", crowned by a sickle moon and playing pipes.

[I.G.R.]

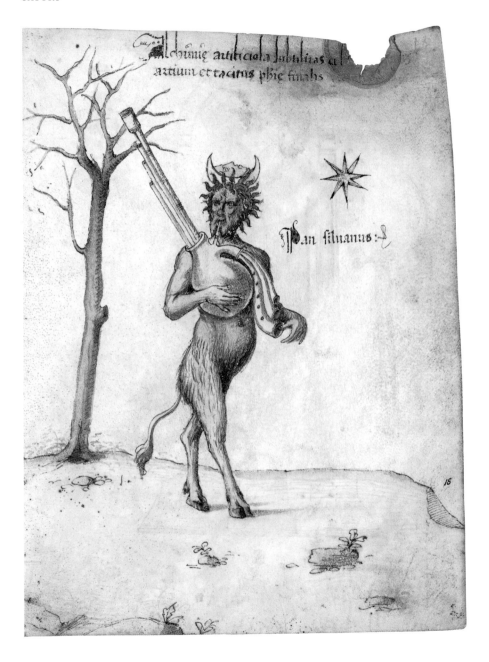

15. Collection of inscriptions and drawings

Florence, Biblioteca Medicea Laurenziana, Ashburnham 1174
last quarter of the 15th century

This miscellany is in two parts, one in Latin and one in Greek. The Latin section contains texts by various classical and contemporary authors, together with inscriptions drawn from the collection assembled by the humanist and antiquarian Cyriacus of Ancona (1391–1452) during his journeys through Italy, Greece, Asia Minor and Egypt. The Greek section comprises texts, inscriptions and various drawings. The manuscript was largely written by Pier-filippo Pandolfini, its owner, with some notes by Bartolomeo Fonzio. The drawings are attributed to at least two different Florentine artists.

Facing each other on fols. 136v–7r are two satyrs.

[A.R.F.]

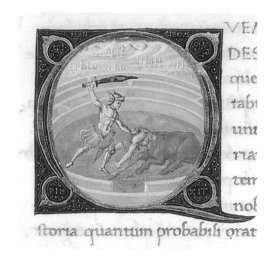

16. Plutarch, *Parallel Lives*

Florence, Biblioteca Medicea Laurenziana, Pluteo 65.26
15th century (*c.* 1463)

This is the first volume of a Latin translation of Plutarch's *Lives* by various humanists; the second volume is contained in Pluteo 65.27.

Written by Piero di Benedetto Strozzi and illuminated by Francesco di Antonio del Chierico, the codex was probably produced for Lorenzo the Magnificent, although inventory documents and the ex-libris inscription at the end of the volume indicate that it was part of the library collection of his father Piero di Cosimo de' Medici.

Inside the initial *Q* of fol. 2r is Theseus slaying the Minotaur. On the blue background is the signature of the illuminator, FRANCISCVS PINXIT ('Francesco painted [this]').

[A.R.F.]

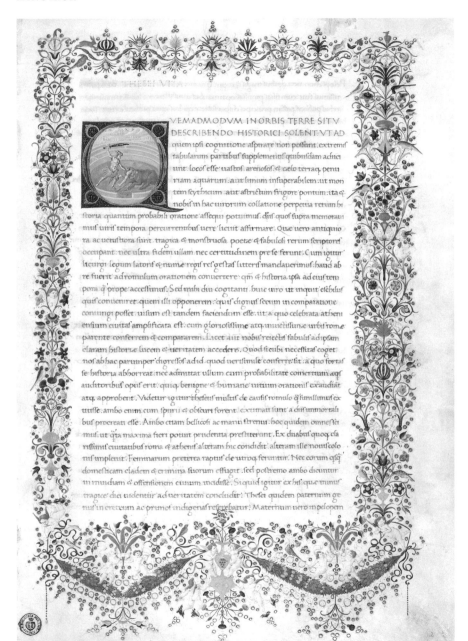

QVEMADMODVM IN ORBIS TERRE SITV
DESCRIBENDO HISTORICI SOLENT VT AD
quem ipsi cognitione aspirare non possint. extremis
tabularum partibus supplementis quibusdam adscri
unt. locos esse uastos arenosos & celo terraq, penu
riam aquarum. aut limum insuperabilem. ut mon
tem scythicum. aut astrictum frigore pontum. ita ẽ
nobis in hac uirorum collatione perpetua rerum hi
storia. quantum probabili oratione assequi potuimus. diis quos supra memora
uimus uiris tempora percurrentibus uere licuit affirmare. Que uero antiquio
ra ac uetustiora sunt. tragica & monstruosa. poete & fabulosi rerum scriptores
occupant. nec ultra fidem ullam nec certitudinem pre se ferunt. Cum igitur
licurgi legum latoris & nume regis res gestas litteris mandauerimus. haud ab
re fuerit ad romulum orationem conuertere. qm̃ & historia ipsa ad eius tem
pora ĩ prope accessimus. Sed mihi diu cogitanti. hunc uiro ut inquit eschilus
quis conueniret. quem illi opponerem. quis dignus secum in comparatione
contingi posset. uisum est tandem faciendum esse. ut a quo celebrata atheni
ensium ciuitas amplificata est. cum gloriosissime atq, inuictissime urbis rome
parente conferrem & compararem. Liceat aũt nobis reiectis fabulis ad ipsam
claram historie lucem & ueritatem accedere. Quod si cubi necessitas coget
nos ab hac parumper digressos ad id quod uerisimile conferre sit. a quo fortas
se historia abhorreat. nec admittat ullum cum probabilitate commercium. aeq
auditoribus opus erit. quiq, benigne & humane uitium orationis exaudiat
atq, approbent. Videtur igitur theseus multis de causis romulo ĩ similimus ex
titisse. ambo enim. cum spurii & obscuri forent. extimati sunt a diis immortali
bus procreati esse. Ambo etiam bellicosi ac manu strenui. hoc quidem omnes sci
mus. ut qͭa maxima fieri potuit prudentia prestiterunt. Ex duabus quoq, cla
rissimis ciuitatibus roma & athenis. alteram hic condidit. alteram ille nouts colo
nis impleuit. Feminarum preterea raptus de utroq, feruntur. Nec eorum quͭg
domesticam cladem & crimina suorum effugit. sed postremo ambo dicuntur
in municiam & offensionem ciuium incidisse. Si quid igitur ex his que minus
tragice dici uidentur. ad ueritatem concludit. Theseus quidem paternum ge
nus in erectum ac primos indigenas referebatur. Maternum uero ĩ pelopen

17. *Book of Hours*, Use of Rouen

Florence, Biblioteca Medicea Laurenziana, Mediceo Palatino 11
16th century (1502)

This small prayer book, richly illuminated throughout, was possibly produced for Anne of Brittany (1477–1514), the widow of Charles VIII (d. 1498) who subsequently (1499) married Louis XII; she may be the figure depicted on fol. 121r. After changing hands a number of times, the book was acquired by the Library in 1783.

The folio on display is 70v, depicting the Coronation of Mary which illustrates the Office of the Blessed Virgin; in the illuminated border there are decorative plant and animal motifs, including imaginary creatures like the dragon. On the following pages are reproductions of fols. 62v and 92v, depicting the Presentation in the Temple and the Descent of the Holy Spirit.

[A.R.F.]

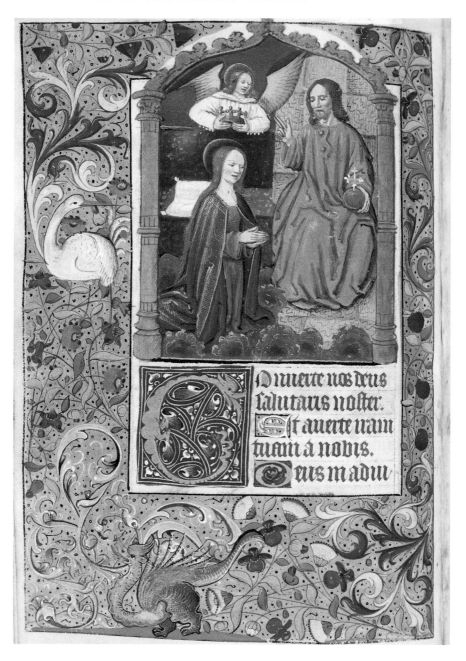

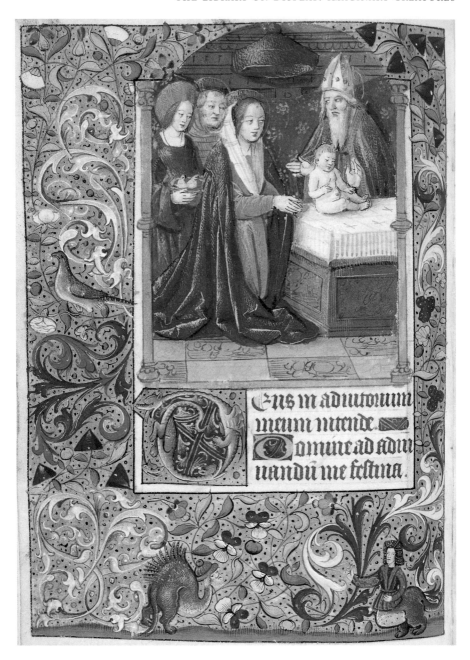

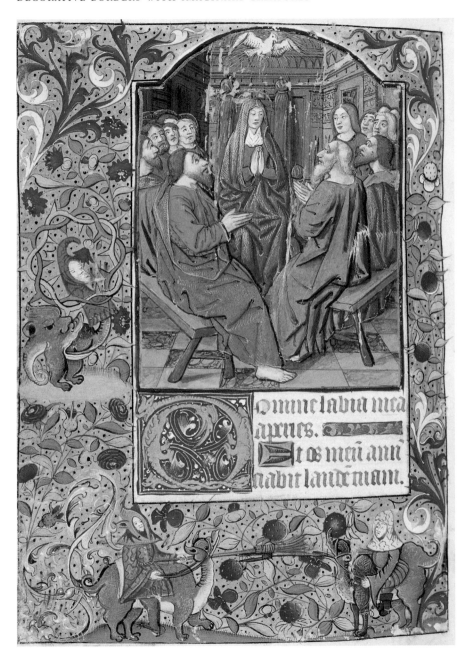

18. Collection of speeches and letters

Florence, Biblioteca Medicea Laurenziana, Pluteo 47.35
second half of the 15th century

The codex contains a selection of Latin speeches by classical authors such as Livy, Virgil, Lucan, Sallust and Ovid, and the *Epistolae ad exercitationem accomodatae*, a collection of model letters assembled by Gasparino Barzizza (d. 1431) and intended for teaching purposes. Written by "Hubertus W.", probably in the 1470s, and possibly decorated by Mariano del Buono, the codex belonged to Francesco Sassetti, as proven by the ownership note on fol. 283r and by the device in the lower part of the border on fol. 1r. On the same folio, in the foliate and white vine-stem border adorned with roundels and insets, there are various mythological scenes and characters: Mercury as a child, an armed Minerva, a man and a lion in combat, and a centaur with a bear. The border also incorporates putti and animals, including a squirrel, an owl and a host of other birds; the lower section contains the Sassetti arms in a gold roundel supported by two centaurs, under which there are two monkeys.

[E.A.]

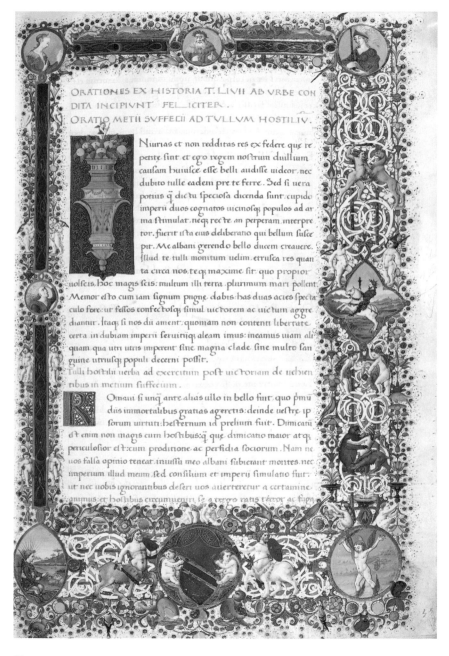

ORATIONES EX HISTORIA T. LIVII AB VRBE CON
DITA INCIPIVNT FELICITER.
ORATIO METII SVFFECII AD TVLLVM HOSTILIV.

Niurias et non redditas res ex federe que re
petite sint et ego regem nostrum duillum
causam huiusce esse belli audisse uideor. nec
dubito tulle eadem pre te ferre. Sed si uera
potius q dictu speciosa dicenda sunt. cupido
imperii duos cognatos uicinosq populos ad ar
ma stimulat. neq recte an perperam interpre
tor. fuerit ista eius deliberatio qui bellum susce
pit. Me albani gerendo bello ducem creauere.
Illud te tulli monitum uelim. etrusca res quan
ta circa nos. teq maxime sit. quo propior
uolscis. hoc magis scis. multum illi terra. plurimum mari pollent.
Memor esto cum iam signum pugne. dabis. has duas acies specta
culo fore. ut fessos confectosq simul uictorem ac uictum aggre
diantur. Itaq si nos dii ament. quoniam non contenti libertate
certa in dubiam imperii seruitiq aleam imus: ineamus uiam ali
quam qua utri utris imperent sine magna clade. sine multo san
guine utriusq populi decerni possit.
Tulli hostilii uerba ad exercitum post uictoriam de uehien
tibus in metium suffecium.

Omam si unq ante alias ullo in bello fuit. quo pmu
diis immortalibus gratias ageretis: deinde uestre ip
sorum uirtuti: hesternum id prelium fuit. Dimicatu
e enim non magis cum hostibus: q que dimicatio maior atq
periculosior est: cum proditione ac perfidia sociorum. Nam ne
uos falsa opinio teneat. iniussu meo albani subierant montes. nec
imperium illud meum. sed consilium et imperii simulatio fuit.
ut nec uobis ignorantibus deseri uos auerteretur a certamine
animus. et hostibus circumueniri. se a tergo ratis terror ac fuga

quam, qua utri utris imperent sine mag
guine utriusq; populi decerni possit.
Tulli hostilii uerba ad exercitum pc
tibus in metium suffecium.

Omani si unq ante alias ul
diis immortalibus gratias
sorum uirtuti. hesternum
est enim non magis cum hostibus: q
periculosior est: cum proditione ac p
uos falsa opinio teneat. iniussu meo al
imperium illud meum. sed consilium
ut nec uobis ignorantibus deseri uos
animus: et hostibus circumueniri se

lade sine multo san

ctoriam de uehien

bello fuit, quo ꝓmū
ns: deinde ueſtre ip
lium fuit. Dimicatū
imicatio maior atꝗ
a ſociorum. Nam ne
ubierant montes, nec
perij ſimulatio fuit:
teretur a certamine
o ratis térror ac fuga

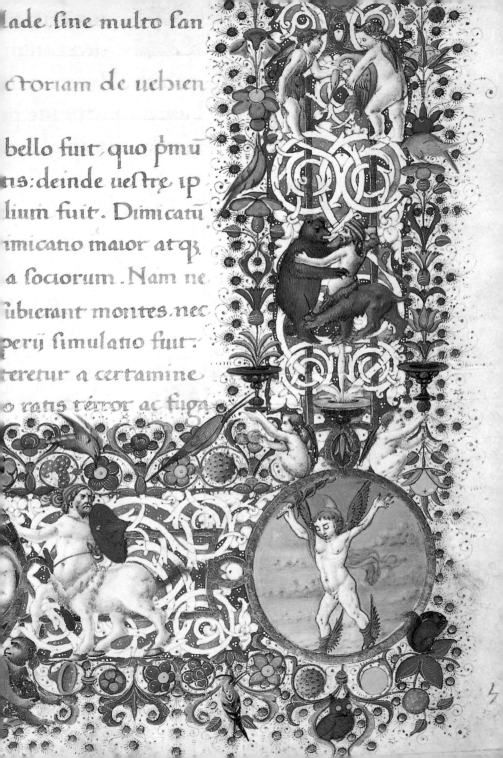

19. Pliny the Elder, *Natural History*

Florence, Biblioteca Medicea Laurenziana, Pluteo 82.3
second half of the 15th century

The codex has been identified as the "Pliny" referred to by the stationer Vespasiano da Bisticci in two letters to his patron Piero di Cosimo de' Medici, where mention is made of a manuscript written by Ser Benedetto and completed by June 1458. The impressive decoration has been attributed to Francesco di Antonio del Chierico, the artist who headed one of the leading illumination workshops in Florence in the second half of the 15th century.

The folio on display (4r), containing the beginning of Pliny's dedicatory epistle to Emperor Titus, has an extraordinarily rich white vine-stem border. Standing out in the lower section are the arms of the Medici family encircled by a diamond ring, the emblem of the house. In addition to insets inhabited by human figures, the border also incorporates various animals, including a bear ridden by a putto, a rabbit, a butterfly, deer, birds, wild boars ridden by jousting putti, centaurs and other imaginary creatures.

[E.A.]

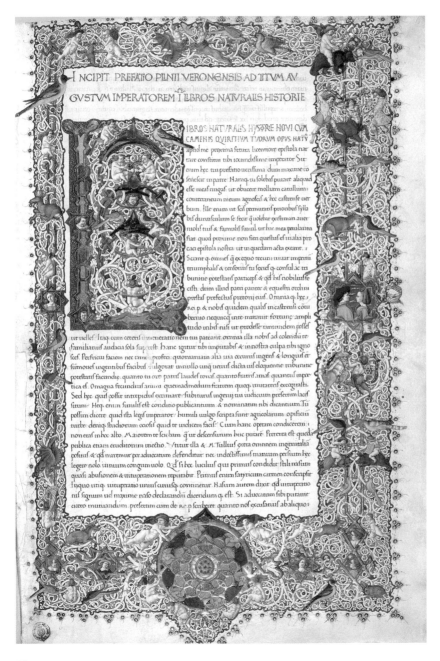

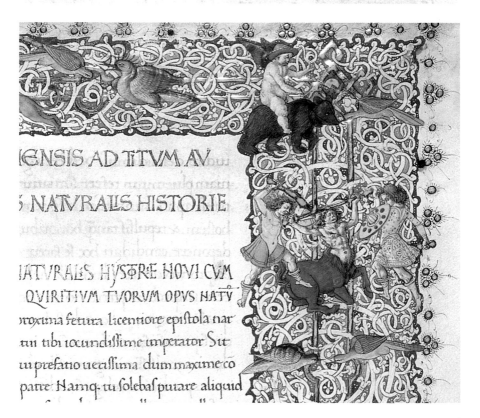

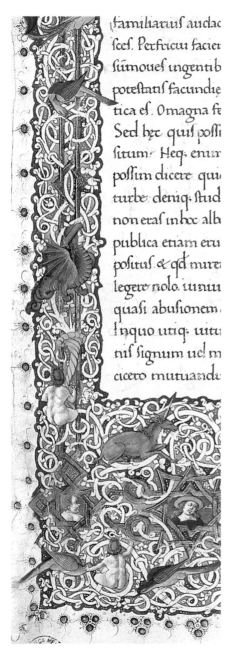

ſamiliariuſ audac
ſceſ. Perfricui facier
ſumoueſ ingentib
poteſtatiſ facundię
tica eſ. O magna fe
Sed hęc quiſ poſſi
ſitum· Heq; enim
poſſim dicere qui
turbe deniq; ſtud
non eraſ in hoc alb
publica etiam eru
poſituſ & qd mirer
legere nolo· iunui
quaſi abuſionem
Inquo utiq; uitu
niſ ſignum uel m
cicero mutuand.

PRINTED BOOKS

20. Roberto Valturio, *De re militari*

[Verona], Johannes Nicolai de Verona, 1472
Florence, Biblioteca Medicea Laurenziana, Inc. 2.10

Written by the humanist Roberto Valturio of Rimini (1405–75) in praise of the military skills of Sigismondo Pandolfo Malatesta, this celebrated work spawned many manuscripts and printed editions, including some in the vernacular. The woodcut prints illustrating the text, which have been attributed to Matteo de' Pasti or his circle, provide valuable information about the art of warfare in the Middle Ages.

The woodcut on display depicts the *Arabica machina*, so named because, according to Valturio, it was invented by the Arabs. This fantastic dragon-shaped device was mounted on rollers and contained a cannon in its mouth.

The volume belonged to Giorgio Antonio Vespucci (*c.* 1434–1514) and comes from the library of the Convent of San Marco in Florence.

[L.B.]

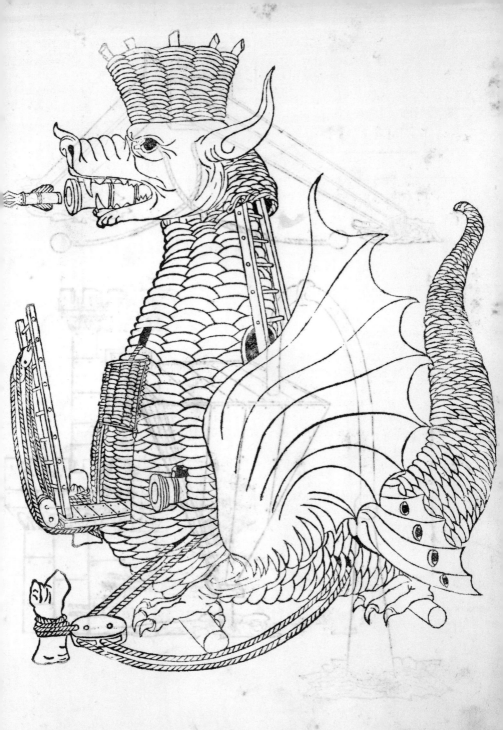

166

21. *Hortus Sanitatis*

Impressum Venetijs, per Bernardinum Benalium et Ioannem de Cereto de Tridino alias Tacuinum, 1511
Florence, Biblioteca Medicea Laurenziana, 22.3.1

The *Hortus Sanitatis* was the first printed book to contain illustrations of animals. Many
editions appeared over the years, from the *editio princeps* printed by Jacob Meydenbach from
Mainz in 1491 to the last complete edition, in German, by Hermann Gülfferich of Frankfurt
(1552). Translations of parts or all of the work also circulated in French, English and Dutch,
as did abridged versions for less learned readers.
 The work is open at fol. H1, which depicts the basilisk, a mythical animal hatched from
a cock's egg; everything its gaze fell upon became arid, and the creature was therefore fated
to live in the desert of its own making.
 The volume comes from the library of the Convent of San Marco.

[L.B.]

De Auibus.

que legibus non obtéperant : penitentie con-
demnatione seipsas mulctãt vt aculei sui vul-
nere moziantur. ¶Ambzosius. Pulle autez
apes e domibus audét exire: nec in aliquos p-
cedere pastus: nisi rex pzius egressus sibi ven-
dicauerit pzincipatuz volatus. ¶Pzocessus au
tem earũ est per rura redolentia vbi ozti sunt
redundantes flozibus: fluensqz cuius per gra-
mina: herbisqz dulcibus pzima ponũt castro-
rum fundamenta. Apes ozdinãt ad opa di-
uersa. Pã flozes adducũt queda: alie mollifi-
cant cerã: z alie adducunt aquã. Earũqz ope-
rationes tépus determinatum nõ habent: sed
cũ habuerint res cõueniétes subito pzeparãt:
z in sereno tempoze operantur assidue.

¶Uirgilius in Georgicis.
Punc age naturas apib°: quas Jupiter ipse
Abdidit expediam.
Magnanimosqz duces: toti° ex ozdine gétis.
Mozes z studia: z populos: z pzelis.
Rex melioz: vacua iam regnat in aula.
Maculis auro squalentibus ardans.
Et rutilis clarus hic melioz in signis z oze.
Túc trepide iter se coeunt pénisqz cozruscãt.
Spiculaqz eracuũt rostris aptantqz lacertos
Et circum regem mixte glomerãt in ozbem
Ille opez custos illũ admirãt z oés circũstat.
Aerum ipse e foliis natos z suauibus herbis.
Oze legunt ipse regem paruosqz quirites
Sufficiunt aulasqz z cerea regna resigunt.
Tátus amoz floz z generandi glozia mellis.
Pam alie victu inuigilant z federe pacto.
Exercentur agris pars intra septa domozum
Parcifci lachrymã z lentuz de coztice glutế.
Pzia fauis ponũt fundaméta: deide tenaces
Suspendũt ceras alie spem gentis adultans,
Educunt fetus: alie purissima mella.
Feruet op°: redolétqz thimo fragrãtia mella

Operationes

a ¶Aristo. Apes a flozib° accipiũt cerã: z cum
pedibus anteriozib° cõgregãt eaz: dehinc ad
pedes medios illã mittũt: deinde ad coxas pe
dũ posteriozum: postea volant cũ ipsa : z tunc
manifestatur pondcrositas ex ea.

b ¶De virtute z operatione cere lectoz iueniat
superius in tractatu de berbis. de C. in cap.
centesimoquinquagesimopzimo.

c ¶De virtute autem z operatione mellis in-
ueniat in eodem tractatu de M . in capitulo
tricentesimoduodecimo.

Capitulum xiii.

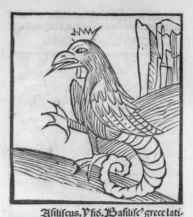

Asilisc°. Y sid°. Basilisc° grece lati-
b ne regulus interpzetatur: eo q rex ser-
pentum sit: adeo vt videntes eum fu-
giant: quia olofactu suo eos necat. Pam z ho
minem vel si aspiciat interimit. siquidem z ei°
aspectum nulla auis volans illesa pertransit.
Sed q̃uis pzocul sit: eius oze combusta deuo-
ratur. ¶Auice. in. iiij. can. Basiliscus est ser
pens qui solo visu interficit z audituvócis sue.
Punc ait quidam vocari regulũ: qz caput ha
bet coronatum: cuius longitudo duaruin pal
marum est: z caput acutum valde: oculi rubei
Coloz eius ad nigredinem z citrinitatem de-
clinans. Hic adurit totũ quod incedit: nec in
circũitu cauerne eius vzitur aliquid. ¶Ex li-
bzo de naturis rerum. Basiliscus interdus ex
gallo nascitur: quia gallus in etate decrepita
facit ouum ex se vnde basiliscus pzocreaŧ. Sz
in generatione hac opoztet vt multa zcurrãt.
Jn fimo nãqz calido z multo ponit ouũ : ibiqz
fouetur vice patris : z post multum tempozis
erit pullus z inualescit sicut solent a natũ pul
li. Pabet autem caudam vt coluber: residuuz
vero cozp° vt gallus. Dicunt aũt hi q creatio
nez eius se vidisse testanŧ q nulla est oui testa:
sed validissima pellis: intãtũ vt resistere possit
ictibus validissimis. Opinio quoqz quozũdaz
est: q ouum illud galli coluber aut bufo foue-
at. Sed hoc incertum est: hoc tñ in antiquozũ
scriptis habemus: q basilisci quoddaz genus
ex ouo galli decrepiti generetur. ¶Y sidozus.
A mustelis basiliscus vincitur : quas illic ho-
mines inferũt cauernis qbus delitescit. Jtaqz
eo visu fugit quem illa persequitur z occidit.
D

22. Ovid, *Works*

Bologna, Baldassarre Azzoguidi, 1471
Florence, Biblioteca Medicea Laurenziana, D'Elci 595

This volume of Ovid's works is part of the celebrated collection of first editions of Greek and Latin authors belonging to Angelo Maria D'Elci (1754–1824), who later donated them to the Biblioteca Laurenziana. Many pages are missing from the book, and the collector clearly reassembled it by inserting leaves and quires of varying provenance. Perhaps this explains the unusual position in the book of the illuminated border on display here, which is found at the beginning of the *Metamorphoses* (fol. [78]).

The illumination features Tritons armed with shields and swords in the side panels of the base, while in the central panel a Triton carrying a Nereid on its back is simultaneously confronting a dragon.

[L.B.]

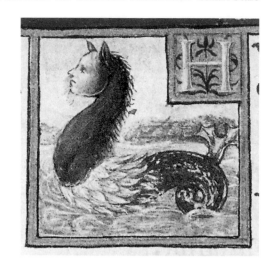

23. Horace, *Works*

Venetiis, apud Aldum Romanum, mense Maio 1501
Florence, Biblioteca Medicea Laurenziana, D'Elci 516

After the edition of Virgil of April 1501, this volume of Horace's works is the second pocket-size book printed in italic typeface by Aldus Manutius.

The D'Elci edition was finely illuminated by a highly skilled artist, probably Jacopo di Antonio Giallo (15th–16th century); the artist's technique is revealed in the great attention to detail and the constantly varying combinations of colours, from the first two leaves sumptuously decorated with architectural motifs to the sophisticated initials of the poems.

The exquisite illumination framing the initial *H* of fol. k1 depicts, in an abstract river landscape, a monster with a woman's face, the neck of a horse, feathered limbs and a vigorous fish tail that recalls the beginning of *Ars poetica* (see no. 11).

[L.B.]

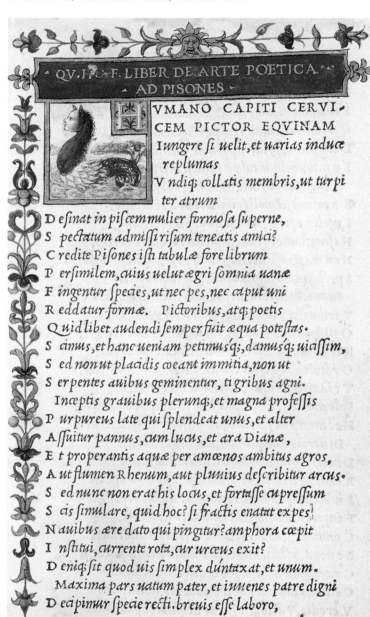

· QV. H. F. LIBER DE ARTE POETICA ·
· AD PISONES ·

VMANO CAPITI CERVI-
CEM PICTOR EQVINAM
Iungere si uelit, et uarias inducæ
replumas
Vndiq; collatis membris, ut turpi
ter atrum
Desinat in piscem mulier formosa superne,
Spectatum admissi risum teneatis amici?
Credite Pisones isti tabulæ fore librum
Persimilem, cuius uelut ægri somnia uanæ
Fingentur species, ut nec pes, nec caput uni
Reddatur formæ. Pictoribus, atq; poetis
Quidlibet audendi semper fuit æqua potestas.
Scimus, et hanc ueniam petimus'q; damus'q; uicissim,
Sed non ut placidis coeant immitia, non ut
Serpentes auibus geminentur, tigribus agni.
Inceptis grauibus plerunq; et magna professis
Purpureus late qui splendeat unus, et alter
Assuitur pannus, cum lucus, et ara Dianæ,
Et properantis aquæ per amœnos ambitus agros,
Aut flumen Rhenum, aut pluuius describitur arcus.
Sed nunc non erat his locus, et fortasse cupressum
Scis simulare, quid hoc? si fractis enatat ex pes]
Nauibus ære dato qui pingitur? amphora cœpit
Institui, currente rota, cur urceus exit?
Deniq; sit quod uis simplex dúntaxat, et unum.
Maxima pars uatum pater, et iuuenes patre digni
Decipimur specie recti. breuis esse laboro,

k

67

24. *Mythographi Latini*

Auctores mythographi Latini. Lugd[uni] Bat[avorum], apud Samuelem Luchtmans; Amstelaed[ami],
J. Wetstenium et G. Smith, 1742
Florence, Biblioteca Medicea Laurenziana, 23.3.51

This is a collection of Latin texts by authors from the 1st to the 13th century (the Latin writers Hyginus, Fulgentius and Lactantius Placidus, and "Albricus philosophus", the mythographer Alberic of London), whose chiefly philological interest in myths continued a tradition dating all the way back to the Hellenistic age.

On display here is the engraved frontispiece. On the bottom right is the date, 1741, and on the left the name of the engraver: "F. v. Bleyswyck". In the left foreground of a busy landscape crowded with mythological and allegorical figures, the three-headed Cerberus is guarding the entrance to the Underworld; further back, almost in the centre, is the Minotaur, the legendary creature—half man and half bull—slain by Theseus with the help of Ariadne.

[A.S.]

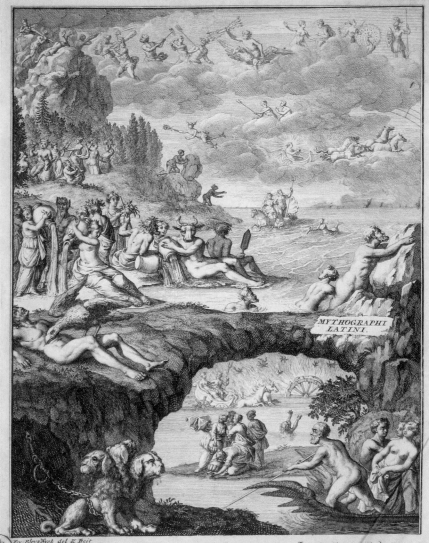

MYTHOGRAPHI LATINI.

LUGDUNI BATAVORUM Apud SAMUELEM LUCHTMANS.
AMSTELODAMI Apud J: WETSTENIUM et G: SMITH. } 1741.

25. Aristotle, *History of Animals*, in Greek

Venetiis, in domo Aldi, mense Ianuario 1497
Florence, Biblioteca Medicea Laurenziana, D'Elci 857

This is the third volume in a five-part edition of Aristotle's works published by Aldus Manutius the Elder between 1495 and 1498. The title page is decorated with an illuminated border, attributed, at least in part, to Attavante, a prominent illuminator who is known to have worked on a large number of codices, including some for the Medici family. The right-hand side of the border was clearly added at a later date. Amongst the imaginary creatures are a unicorn, a snake with a bearded human head and a small winged dragon.

The D'Elci volume was once in the collection of Matteo Battiferri (15th–16th century), a physician from Urbino; his emblem can be seen on the folio on display.

[A.S.]

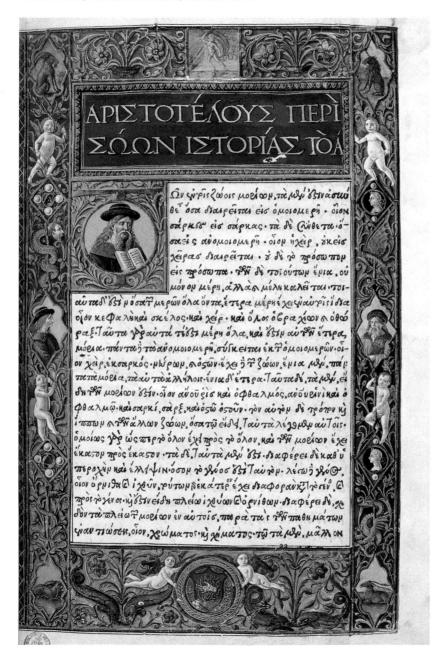

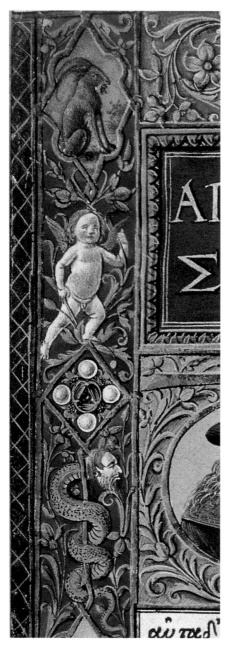
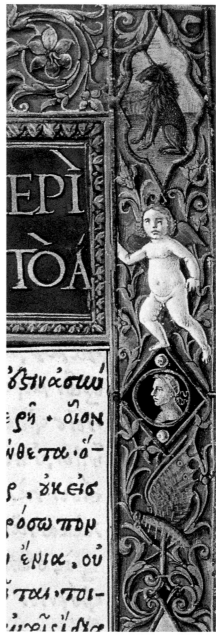

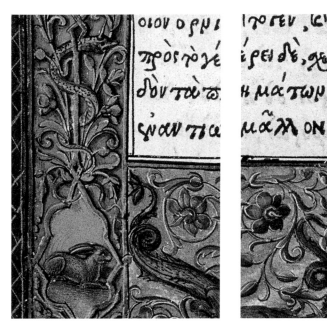

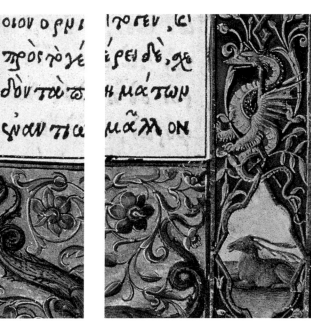

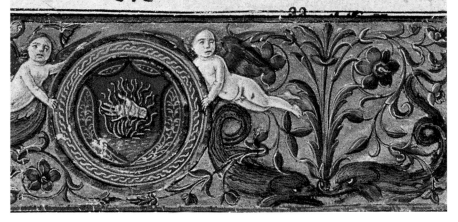

26. *Retorica di ser Brunetto Latini*, in Florentine vernacular

Stampata in Roma in Campo di Fiore per M. Valerio Dorico, & Luigi Fratelli Bresciani, 1546
Florence, Biblioteca Medicea Laurenziana, 22.4.24

This edition contains a translation by Brunetto Latini (the Florentine scholar and master of rhetoric who for a time had Dante as his pupil) of the first 24 paragraphs of Cicero's *De inventione*, accompanied by a commentary.

The folio on display, N3v, bears the colophon specifying where and by whom the book was printed. The printers were in business together in Campo dei Fiori until 1559, when they moved to the Chiavica di Santa Lucia in Via del Pellegrino.

In the printer's emblem Pegasus is striking Mount Helicon with his hoof, and the fountain Hippocrene (literally, the 'fountain of the horse') is gushing out from the side of the mountain; running around the image is the motto *Invia virtuti nulla est via* ('To virtue, no way is barred', Ov. *Met.* 14. 113).

The volume comes from the library of the Convent of San Marco.

[L.B.]

tra parare nel ſuo dire ricordo come egli era amato da Talamone, il quale altra fiata preſe Troia al tempo del forte Hercole. Et coſi mettea auanti la perſoſ na amata, & gratioſa in luogo di ſe, & in ſuo aiuto per piacere alla gente, & per hauere buona cauſa. Et quando la cauſa è laida per cagione di mala coſa douiamo noi recare nel noſtro parlamento un'altra coſa buona, & piaceuole, ſi come fece Catellina ſcuſandoſi della congiuratione che fece in Roma che fece una giuſta coſa per coprire quella rea dicendo egli. ᴀ E ſtata mia uſanƷa di pren dere à aiutare li miſeri nelle loro cauſe.

¶ Stampata in Roma in Campo di Fiore per. M. Valerio Dorico, & Luigi Fratelli Breſciani, nell'Anno.
M. D. XLVI.

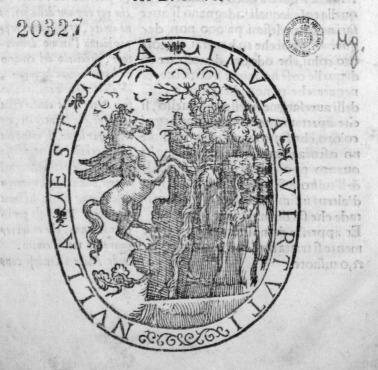

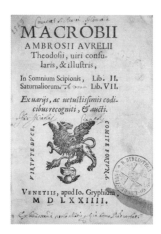 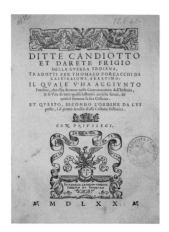

27. Macrobius, *Commentarii in Somnium Scipionis*; *Saturnalia*

In Somnium Scipionis, Lib. II. Saturnaliorum, Lib. VII. Venetiis, apud Io. Gryphium, 1574
Florence, Biblioteca Medicea Laurenziana, 15.F.6.11

This edition contains the commentary on Cicero's *Somnium Scipionis*, a major influence on the philosophical and scientific culture of the Middle Ages, and the *Saturnalia*, a dialogue between scholars banqueting during that festival. The title page, on display, features the emblem of the printer, whose surname, Griffio, often led him to choose the griffin, a mythological creature sacred to Apollo and later a symbol of the ferocity of those who persecuted the Christians. The printer's motto is *Virtute duce, comite fortuna* ('Virtue as a guide, fortune as a companion'). The volume comes from the library of the Convent of San Marco.

28. Dictys Cretensis, *Ephemeris de historia belli Troiani*, in Italian

Ditte Candiotto et Darete Frigio Della guerra troiana, tradotti per Thomaso Porcacchi da Castiglione Arretino. In Vinetia, appresso Gabriel Giolito di Ferrarii, 1570
Florence, Biblioteca Medicea Laurenziana, 12.E.4.2

Supposedly translated into Greek and Latin from an original Phoenician text, these stories were a major source for medieval handlings of the Trojan cycle, including Benoît de Sainte-Maure's *Roman de Troie*. The title page, on display, features the printer's emblem: emerging amidst the flames from an amphora inscribed with the initials "GGF" is the phoenix, the bird that rose from its own ashes; around it is the motto *De la mia morte eterna vita i vivo* ('From my death I live eternal life') and, underneath, *Semper eadem* ('Always the same').

[A.S.]

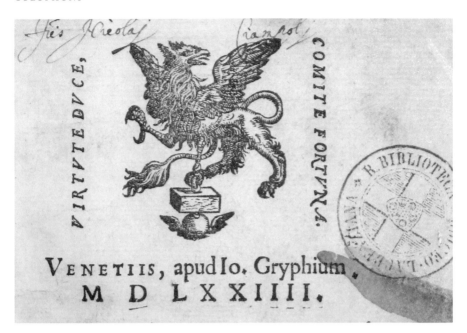

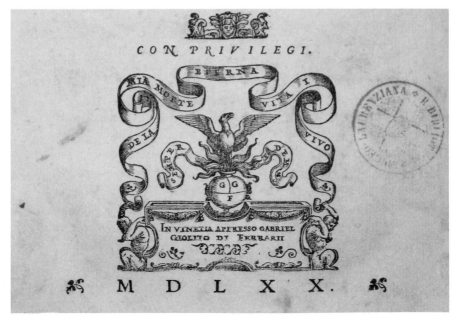

INDEX OF MANUSCRIPTS AND PRINTED BOOKS

TABLE OF CONTENTS

Printed by Alpilito, Firenze
March 2007